THE ARTIST AT WORK IN HER STUDIO

ELIZABETH BLACKADDER RA

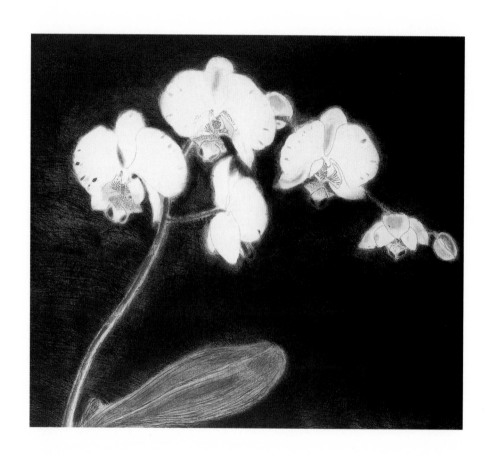

THE ARTIST AT WORK IN HER STUDIO

ELIZABETH BLACKADDER RA

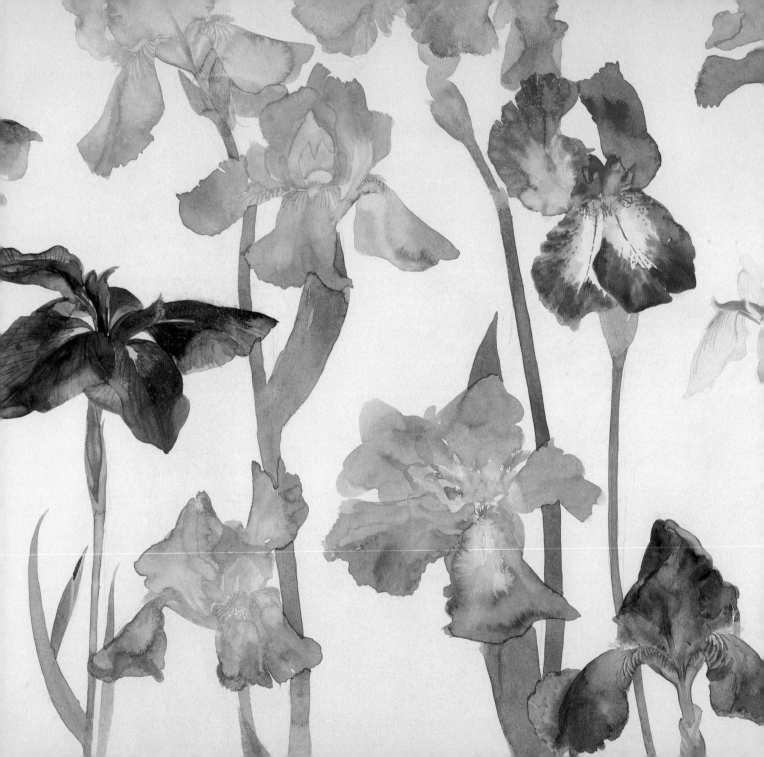

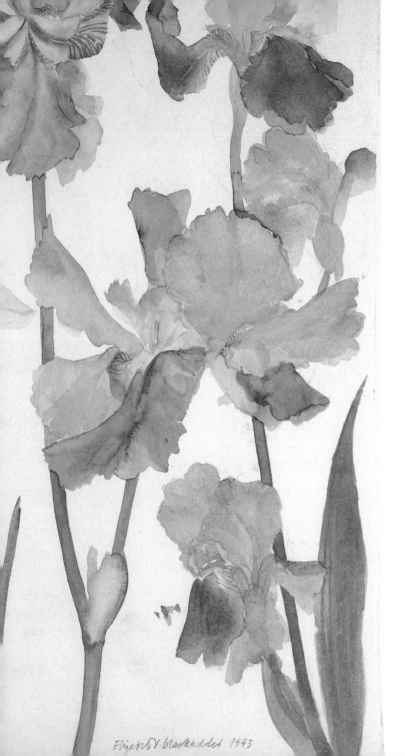

Elizabeth V. Blackadder 1993

CONTENTS

6 ELIZABETH BLACKADDER RA *Michael Leitch*

10 INTRODUCTION

20 TULIPS AND IRISES

46 DARK GLADIOLI

58 BOLOGNA

70 KIMONO

80 JAPANESE STILL LIFE, BLACK AND SILVER

94 SOLO EXHIBITIONS

96 ACKNOWLEDGMENTS

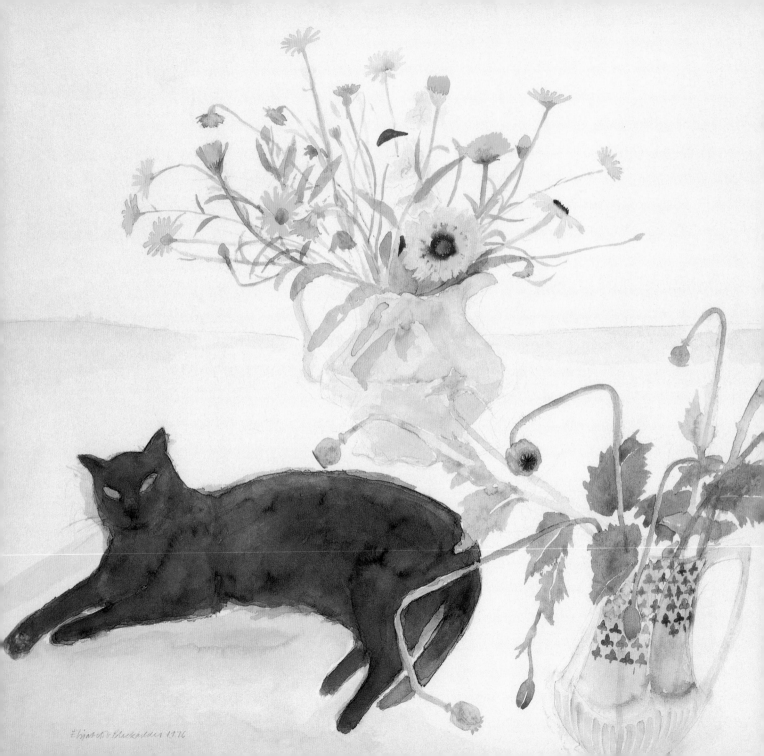

Elizabeth Blackadder 1976

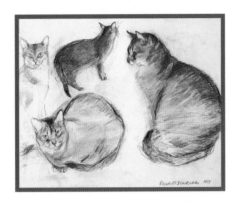

ELIZABETH BLACKADDER RA *by Michael Leitch*

Opposite *Cat and Flowers (1976), watercolour. Cats, and flowers, and sometimes a combination of the two, have long been part of Elizabeth Blackadder's subject range.*

Above *Studies of an Abyssinian Cat (1998), pastel.*

Elizabeth Blackadder is one of Britain's foremost artists, widely known for her work in various different fields, both representational and semi-abstract, all of which reveal her primary concern with the placing of objects in space and their relationship to each other in the overall composition. This applies as much to her fluent watercolours of flowers as it does to her still lifes on Japanese paper, which she has been painting since the early 1970s.

Each of her works is a carefully thought-out arrangement of colours and shapes. These may be grounded firmly in a location, like the landscapes she has drawn and painted all over Europe, or seem to float free like her horizontal Japanese scrolls, and even some of her

7

paintings of flowers and cats, but nearly all of them provide the viewer with an additional, almost mystical element: the invitation to contemplate the space she has created. To look, and read, and try to establish a personal, even spiritual, relationship with the work. It is this element which characterises her paintings, and sets her apart as an artist to be reckoned with.

Elizabeth Blackadder was born in Falkirk in 1931 and studied art at the University of Edinburgh and Edinburgh College of Art. In 1954 she was awarded a Carnegie travelling scholarship by the Royal Scottish Academy and travelled in Italy, Greece and Yugoslavia.

Her first solo exhibition was held at 57 Gallery, Edinburgh in 1959, and since then she has exhibited regularly in Britain, particularly at the Mercury Gallery in London, The Scottish Gallery, Aitken Dott in Edinburgh, and at the Glasgow Print Studio. She has also exhibited in Canada, Italy, Japan, Russia and the United States. She was elected a Member of the Royal Academy in 1976. She is also an Academician of the Royal Scottish Academy, and holds Honorary Doctorates at several Scottish universities. She was awarded the OBE in 1982.

Opposite *Hiiragiya (1985), watercolour. An example of the long, scroll-like arrangements of objects which Elizabeth Blackadder began to develop after her first visit to Japan in the mid-1980s.*

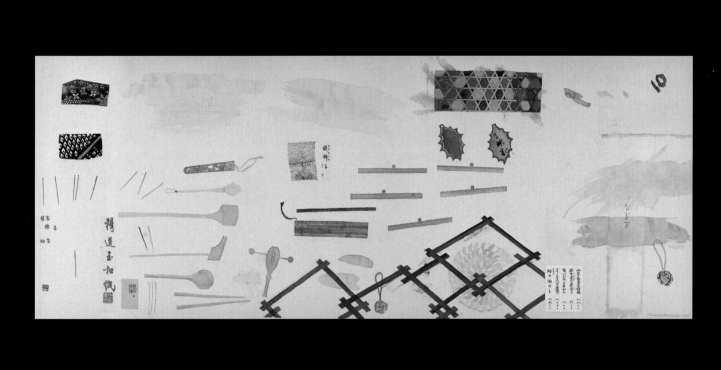

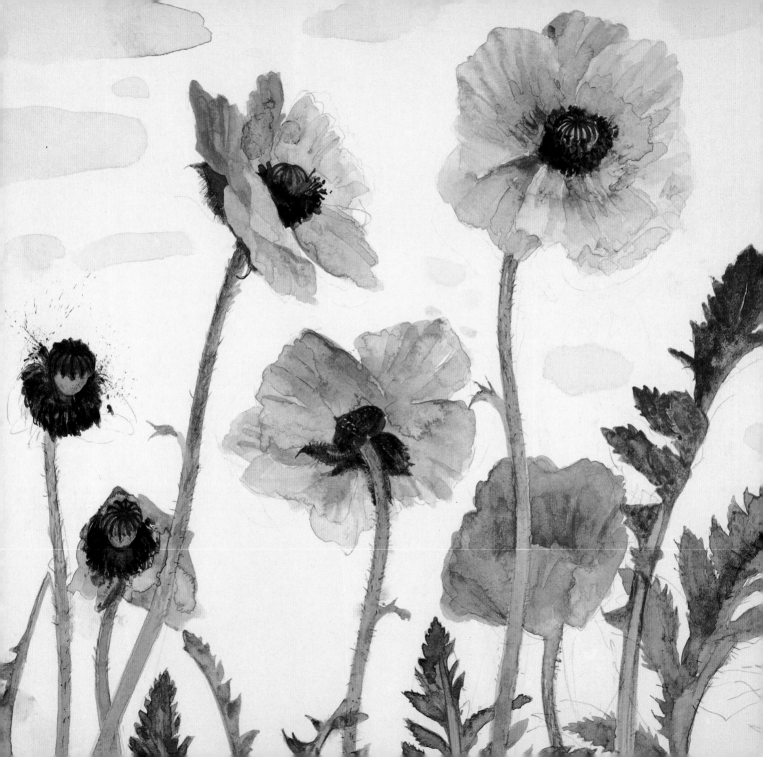

INTRODUCTION

Opposite *Oriental Poppies, detail (1985), watercolour. The petals are mainly painted wet on wet so that the delicate colours blur slightly into one another.*

I enjoy painting different subjects, but I don't see them as different. Someone looking at the paintings might think: 'Oh, she paints lots of different things,' but to me they are not all that different. They are all paintings, and I am always looking for the same kind of solutions or exploring the same visual language through them.

In this book you will see paintings from three different subject areas, and in two different media. There are two flower paintings, one in watercolour and the other in oil, an oil painting of an old building in Bologna, and two paintings that develop Japanese themes. One is a kind of portrait of a kimono in oil, and the other is a semi-abstract arrangement of shapes and recognisable objects on a long scroll, for

11

which I used watercolour, inks and gold leaf in some areas.

Tulips in my garden. They only have a fairly short flowering season, but while they are around they provide me with a good stock of subjects for paintings.

Although these paintings may look different from each other, and use different formats, that is something I quite like to do anyway. I also like to work on more than one painting at a time. One may be a watercolour of flowers, which I will paint in a fairly detailed way, and the other may be a larger oil painting where I have the freedom to work the paint around, scrape out and build up the design as I go along. In the meantime, I will also have other unfinished paintings around, which I have decided to stop work on because I wanted more time to think about where to take them next, or how to deal with a particular area in them.

My paintings all start with an idea. I have an idea of what I want, sometimes it's quite a clear idea, and at other times I just start off, but I prefer not to plan my paintings out too much, I find it's too restricting. I prefer just letting them grow by themselves. I have always liked moving around on a painting, not concentrating on one end but adding a bit here and there, and then looking at it all again to see how I can develop it further, and get an idea of how it might end up.

I can do this with a flower painting just as well as with one of the long scrolls. The flowers tend to dictate the design, as well as the colours, simply because of their own natural shapes, but I still have to decide not only how I'm going to paint them, but also think about where I'm going to place them on the paper and how I want them to relate to each other. The shape of the spaces in between the flowers is also a very important part of the painting, nearly as important as the flowers themselves, and this all needs to be resolved one way or another.

With the scroll paintings, I have more freedom to compose in the space, partly because it is such a long horizontal surface which is meant to be read by moving across it from one end to the other, rather than looking at it from more or less one fixed point. And, whereas flowers are flowers, here I can put in anything I want – a mask, a spoon, a calligraphic symbol, a strip of gold or silver leaf, and so on. As I build up the painting, I am always thinking about how one area relates to the others, whether the shape or scale of something is right.

I usually start with the scroll shape and one or two objects which I think it would be nice to include. I might also want to keep to a fairly

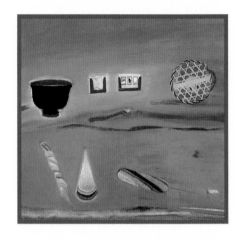

Above *Still Life with Lollipops, oil on canvas.*

Opposite *Shrine, Kyoto (1993), watercolour. This painting combines different grid-like structures typical of Japanese forms. The sprays at bottom left consist of little paper cranes (birds) which the Japanese string together and hang like offerings.*

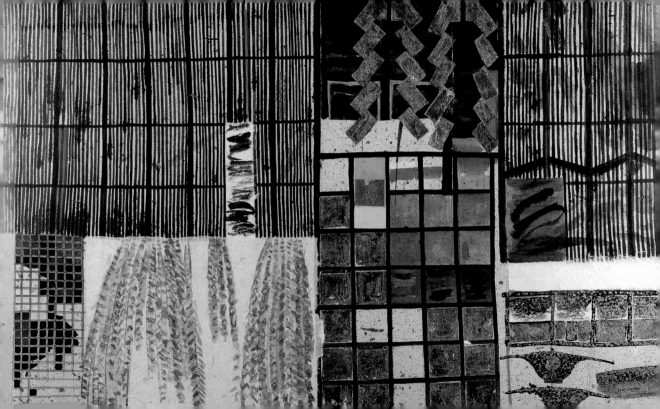

limited tonal range. But at that stage I can never really say how the painting will end up. I would much rather that something new came into it through the process of painting.

All the time I am also trying to create a mood, which I suppose comes from my own recollections in time and place of the various shapes and objects, and the relationship that I have with them. Someone else looking at the finished painting may well read it or relate to its mood in a quite different way, but I don't think that really matters. Everybody has their own set of set of memories and associations to call on, and it is only natural that many people will take a different view. Sometimes people do see the painting as I have done, and I'm delighted when they do, but it is not all that important really. I am happy enough that people do actually make some connection with the work that I do.

Opposite **Opposite** *Wild Flowers (1993), watercolour. This painting shows how I vary the shapes and sizes of flowers in a composition, also the importance of thinking about the shapes in between the different elements.*

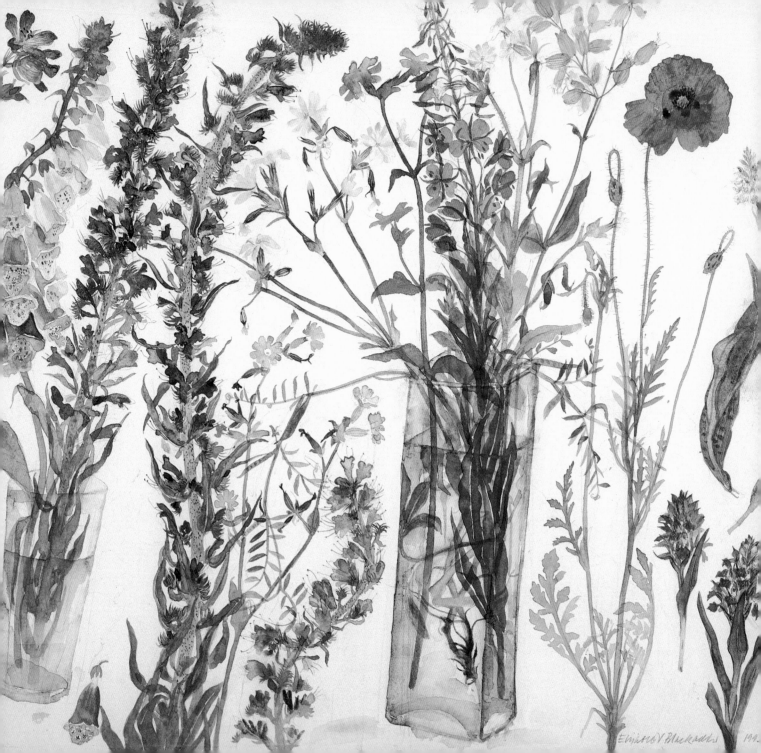

"Whether I am painting flowers or semi-abstract forms, I am using colour to create a particular kind of mood."

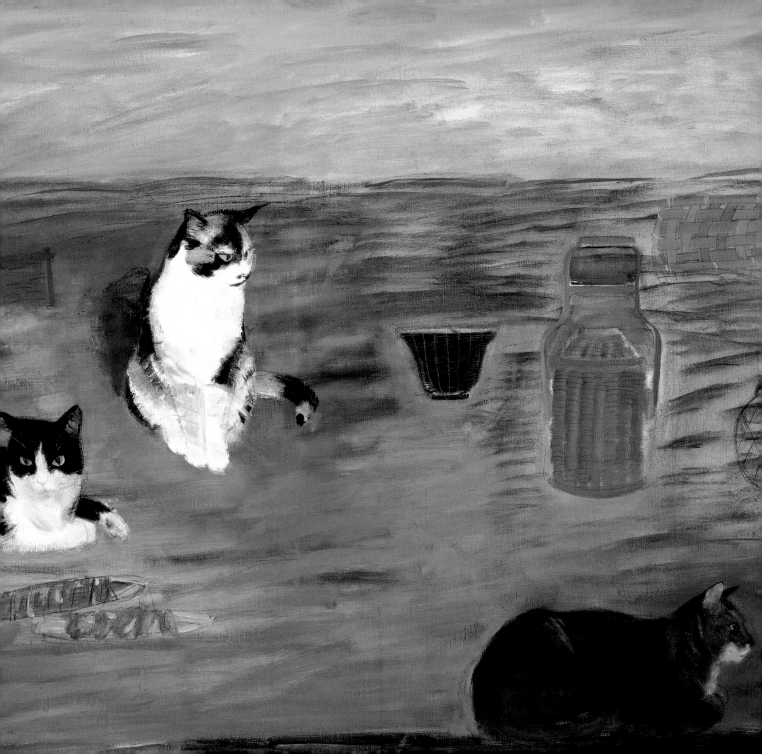

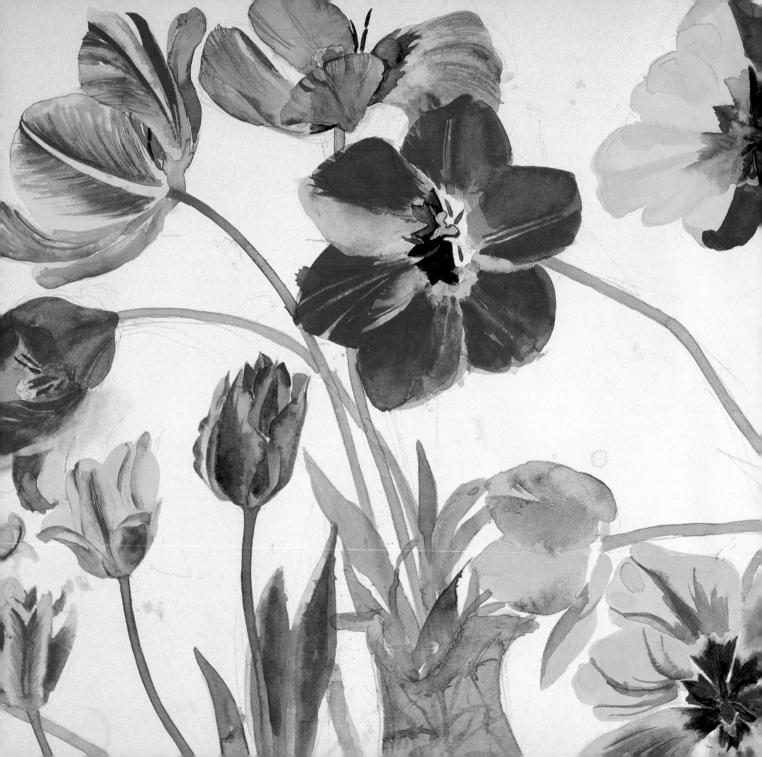

TULIPS & IRISES

Previous page *Still Life with Cats, detail (1991-4), oil on canvas.*

Opposite *Tulips (1994), watercolour. All these tulips come from my garden. The one at top right interested me because it is something of a genetic oddity with its precise division into two halves of red and yellow.*

Above *Before any painting begins, I sometimes set up various likely specimen flowers in vases while I think about what I might do with them.*

I'm going to start a watercolour of flowers. First of all, I'm going to paint some of the tulips which are beginning to look really quite interesting. I usually like to pick them and leave them in the studio for a little while and then they take on their own shapes. The stems curve and the flowers open out and they are much more interesting than when they are first stuck into a vase.

I don't plan out the picture in advance. I have an idea in my head but the idea may change in the course of the painting. Once you start with an image on the white paper, that really dictates in a way what is going to happen next. I really like to be surprised at the end anyway, I don't like it to be too predictable. I think it becomes boring then. I am

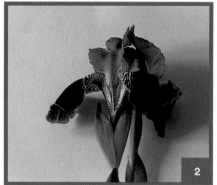

thinking, too, of mixing the varieties of flowers in this painting.

I hope to draw with the paintbrush more than doing a detailed drawing beforehand, although it doesn't always work out like that. I do tend to know where the colours are going to be, and I set them out grouping some of the colours together. I suppose I use quite a big range of colours, especially for painting flowers. I had to do a commission, painting orchids in Malaysia, and they were all pink and magenta – it was quite a problem getting those kinds of colours.

When I am painting flowers like this, I use a fairly smooth, hard-surface paper. Quite a heavy paper, and not absorbent, so the paint tends to lie on top of the paper. This can give you greater detail and a sharper edge. If I was painting a still life, I might use a very soft

1/2 I have selected this iris and am laying it down fairly near the right-hand edge of the paper. I don't always begin on the right, but this iris has a strong shape and I wanted to give it a prominent position and then work round it.

3 Choosing colours from my watercolour box. I also use a lot of tubes of watercolour, and mix them in old white dinner plates. This gives me a big range of colours – which I need to have for painting flowers.

Opposite *Orchid Paphiopedilum lawrenceani (1998), watercolour. This is one of my more 'botanical' paintings. I would not attempt to be a botanical painter, but I have always liked the way the best of them lay out their compositions.*

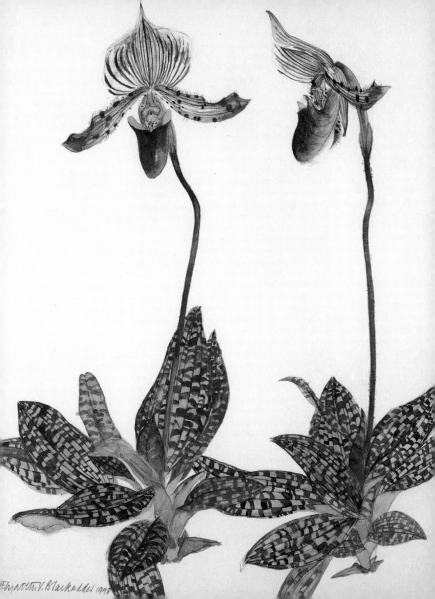

Elizabeth V. Blackadder 1998

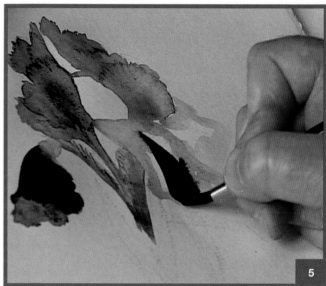

absorbent paper and let the paint flood out over the surface.

My interest in flowers and plants started a long time ago. I was really very interested in botany and in wild flowers. I didn't like garden flowers at all. I drew these wild flowers out of interest, to find out what they were like, how they were put together and so on. Then I started looking at botanical illustrations, and although I could never become a botanical illustrator – I would not have the patience or the knowledge to do it – I am fascinated by botanical paintings by people such as Ehret and the Bauer Brothers, not only because they are scientifically correct but also because they are really seeing as an artist would, and

4/5 These colours are a mixture of purple and magenta, and there may also be some black in the dark parts. Usually, when I am painting petals in watercolour, I like to flood the area of the petal with the main colour and then introduce other colours into it.

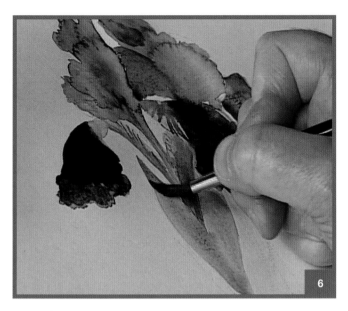
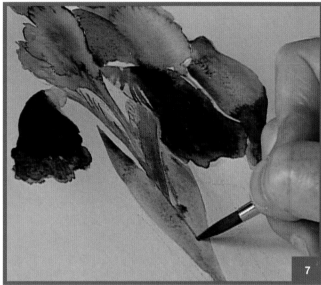

6/7 *Here I have taken the brush down to a fine point to mark where the two leaves divide.*

in the way they place the composition on the paper.

I am fascinated by irises and have started growing them, as many different kinds as I can possibly find. I think I realised that I really like flowers that have quite a strong structure to them. I think the iris has, although there are so many varieties of them. Also I like the texture of the leaves and the petals, with the light shining through them. It is almost impossible to get it in paint but it is always a challenge to try. I never quite manage it, but I keep on doing it.

I have always used watercolour, ever since I was a student, because

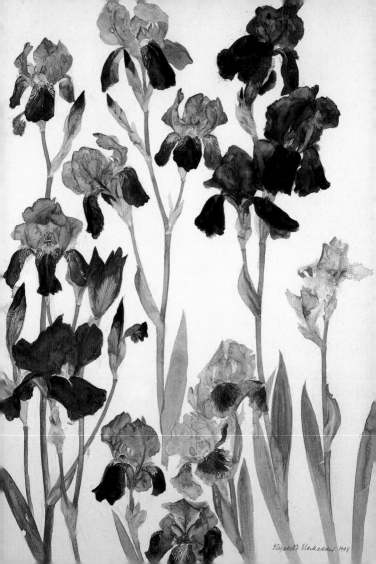

Elizabeth Blackadder 1998

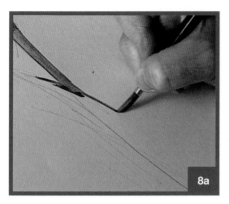

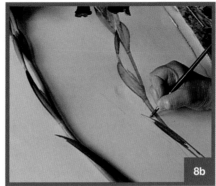

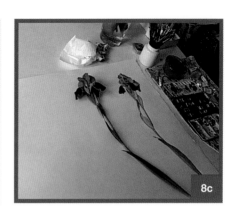

8a *There is a certain amount of underdrawing, but I try to keep this down, otherwise the whole composition can get too tight.*

8b/8c *Here you can see how I place the subject flower next to my painting. Sometimes it can be a problem making the flower stay in the position you want it. They may start to bend of their own accord, and you have to tape them down.*

Opposite *Blue and Purple Irises (1998), watercolour.*

watercolour has been used a lot in Scottish painting for some reason or other. Sometimes people consider watercolour to be perhaps not such a serious medium as oil paint, but it just depends what you want to do, what your idea in the painting is, and to try and see which medium suits that best.

I would now like to go on to some of the other flowers and see how the whole painting is going to build up as a design.

I suppose I am looking at quite a lot of different things. The drawing is quite important to me, that I get the character of the individual plant or flower and also try and get something of the three-dimensional quality of the flower so that it is not just a flat pattern.

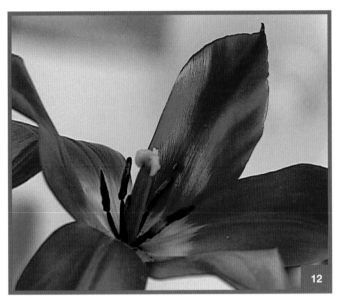

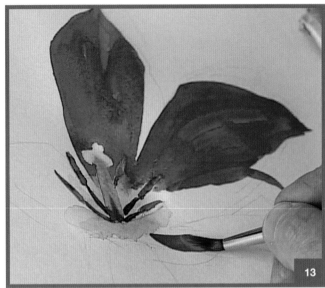

9/10/11 *Drawing in the shape of the tulip and adding the first colours. Here I have begun in the middle of the flower and just touched in the stamens and the stigma. Above this I am putting in the broad shape of the first petal.*

12/13 *You can never get all the fine detail of a petal like this, but you can take colour off here and there, perhaps with a piece of tissue, or put more water on your brush to suggest variations in the texture.*

I use quite a variety of brushes, too. I quite like using some fairly large brushes so that you can get a really full amount of paint on them. The trouble is, if you use very small brushes you tend to get too finicky and too detailed. You need something with a fairly fine point as well.

Once you start looking at a flower like the tulip, it is really very complicated. It has got a totally different kind of texture to the petal from, say, the iris. Some of them are quite shiny and reflective, and the edges of the petals are different too. Some have a slightly broken edge or they twist and turn and one colour blends into another and fades off. You can't hope to get the whole feeling of it, but you can capture

29

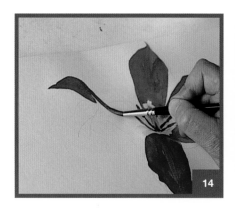
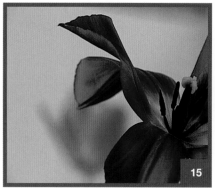
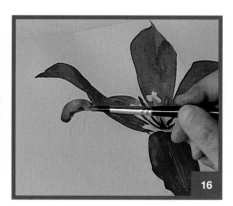

some idea of it by varying your technique - taking colour off, for example, and putting more water on your brush.

To me drawing is really very important. I suppose it is all part of the training that I had, because a great deal of emphasis was put on drawing. On the other hand, if I'm going to do a drawing then I might leave it just as a drawing, but in this case I don't want the drawing to interfere too much with what goes on top. I usually draw with quite a soft pencil, a soluble pencil, so that the lines disappear – or I hope that they will.

Here I'm mainly using Cadmium Red Deep. I paint flowers mostly in watercolour because you get the luminosity of the white paper coming through the paint. At the same time, in the last year or so, I have

14/15/16 The basic colour is Cadmium Red Deep, and I am using various densities of it to show the different tones of the petals, and the way they fold over and catch the light at different angles.

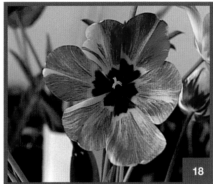
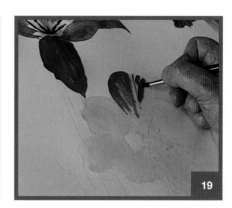

17/18/19 *For this tulip I have put on a fairly strong lemony yellow as a base. Before it is completely dry I add the red to it to get that slight blur where the colours meet. You don't want a hard edge, and you also don't want to let the two colours blend completely.*

also gone back to painting quite a lot of still lives with flowers, but using oil paint.

Here I am just deciding how this tulip is going to work with the iris and where to put in another flower head. This, really, is how the paintings are built up. I don't have a preconceived plan of where everything is going to go. I also like painting flowers almost to their exact size. I don't know quite why this is, but of course the bigger you make the scale the more detail you can get into the flowers. I also like just using the watercolour and letting it run onto the paper.

Sometimes I used to dampen the paper and then paint onto it before it had properly dried. I don't do that so much now but I do paint wet into wet quite often. Especially when I am trying to get an effect like

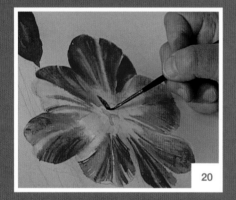

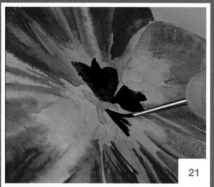

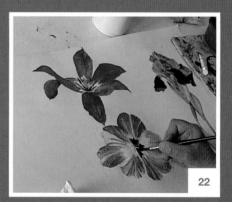

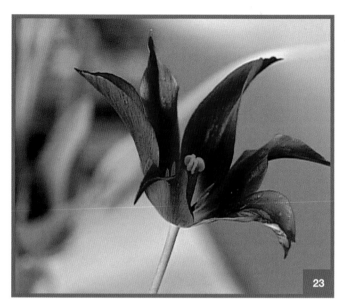

23

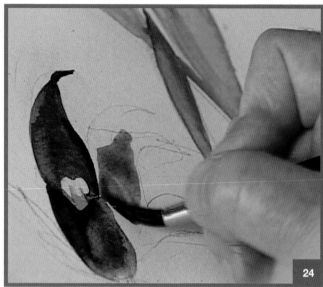

24

20/21 *Here I want a soft black for the middle of the tulip, and am touching the colour in with a fine brush.*

22 *This shows the way the composition is building up, with the first three flowers in place.*

23/24 *On to the lily flowering tulip. As the photograph shows, the tones on these petals are very subtle, and I am trying to capture some of this as I add my colours – basically a mixture of Winsor Violet and magenta.*

this, with the stripes in the tulip, so that the colours blend and the edges become a little softer.

Sometimes I paint in backgrounds or even introduce other objects so that the painting is not just flowers but a mixture of still life objects and flowers. I also quite like having the flowers against just a white background, but sometimes they look a little bit stark, so I might put a very light wash of a rather neutral colour to connect up the flower-heads. Also, if I am putting in jugs or other objects, perhaps I will also paint in some idea of the table surface.

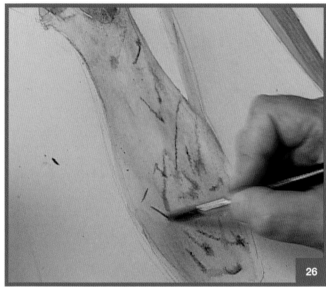

I've got a good range of old jugs and dishes, and some were actually given to me by other painters. I have got one that belonged to Ann Redpath and I think that this little one may well be a Gillies vase.

This is a lily flowering tulip with very pretty, very delicate, very pointed petals and quite unusual colours too. That purple, almost magenta purple colour is just made by using Winsor Violet and, because it's really quite a red violet, I must have put some magenta or some colour like that into it. There is a much bigger range of colours available now than there used to be, especially in these odd colours like Rose or Magenta, and they are also more permanent.

25/26 *Painting in the fine pattern on the vase holding the lily flowering tulip.*

27/28 *Using my hand to decide where to place the next tulip.*

29 *Here I am laying in a basic yellow, as I did earlier with the other red and yellow tulip.*

27

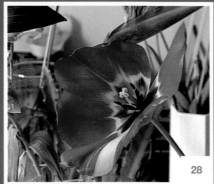

28

29

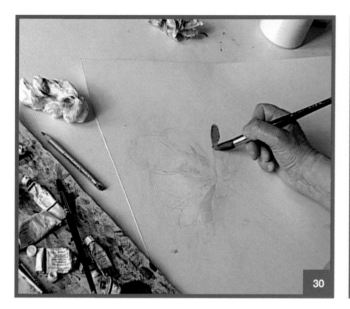

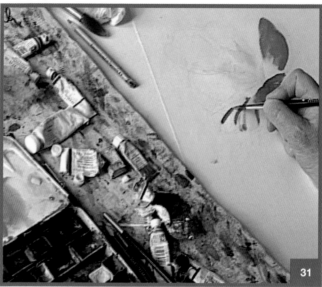

What is already there on the paper now begins to dictate what is going to develop next. I start on the right-hand side and move across. I tend to switch around really quite a lot across the paper. This is a fairly big piece of watercolour paper and I think I'm just seeing how I can roughly plan it out and see what happens. While the painting is building up, I like to move around on the paper rather than completing one end first.

It's really quite odd what happens to some flowers. You find that maybe one half of a petal is red and has a straight line and the other half is yellow – it's really fascinating.

30/31 *Now I am working quite close to the left-hand edge of the paper, and you can see the collection of tubes I have lined up alongside the watercolour box.*

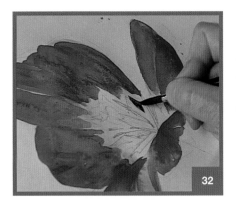

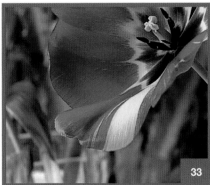

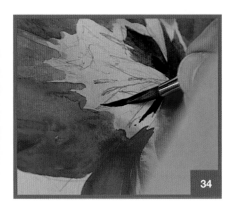

32/33/34 *The bases of the petals are a very subtle blend of greys which it is almost impossible to capture exactly. I am just trying to catch the broad idea of their shapes and colours.*

This colour I'm using for the centre of the flower is not quite black, often it's a bluey black. When I'm using black for the centre of the tulips, I often mix some other colour into the black. You get a lot of different varieties of black. You get a warm black, or a very cold black, or a soft, soft black.

I'll leave this painting now as I've got to let it dry off. I have got the basic structure of it, so it should be OK to come back to later.

Now I've come back and, of course, they've all changed, but it doesn't matter. I sometimes paint the same flower several times because it takes up different shapes which I find interesting. I have also got to think whether perhaps I should put in some foreground here so that some of the flowers can be seen to be resting on a table or something

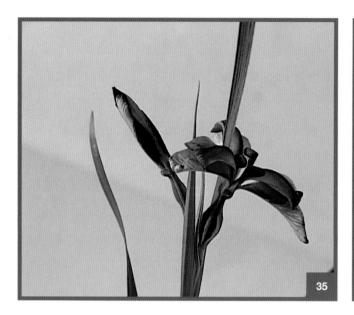

and not just floating on a white background. But that is something I usually don't do until the end.

I think too that it might be quite nice to vary the scale of some of the flowers. I was thinking last night of putting some small things against all these other big, blowsy tulip heads and just come down in scale. Sometimes I do pages of just one type of flower, perhaps more of a botanical study, but in this painting I think I'll have a variety of different things in it.

There is really such variety within the iris group, both in the flowers

35/36 *This is the graminea, a much smaller variety of iris which I am including to vary the scale of the flowers.*

37/38/39 *The veining on the petals is very fine, and the gradations of colour are also quite difficult to paint, especially since the flower is so small.*

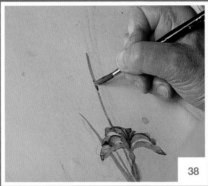

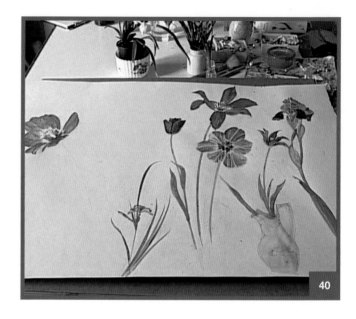

and in the shapes of the leaves and so on. This iris is called graminea. I think somebody gave a root of it to me and it has increased quite well. The big tulips tend to be fairly similar in size, even the big purple iris on the right-hand side is fairly similar, so I thought it would be quite nice to introduce something very different in scale. I like the shape of this iris and the shape of the bud that I am painting just now. It's quite detailed, the sort of veining on the petals, it is quite tricky to get it – and the size of it. I keep thinking it would be nice to go and work on a 6 x 6 foot canvas for a change. That is why I like changing between the two.

40 *Across these pages we can see the composition gradually building up. At this stage I have got a balance of stems leaning to left and right, and they will guide me on where to go next.*

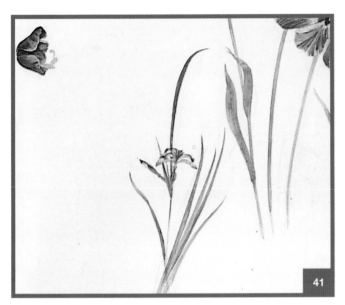

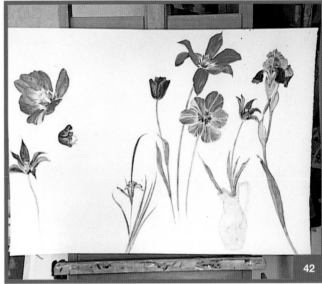

41 *At top left I have added one small flowerhead. Sometimes this happens because I think a flower is not going to last very long, so I have to get it down quickly.*

42 *Now, although there is quite some way to go, the basic composition is in place.*

The trouble is, once you start painting something you are working to an idea, but as the painting goes on you get a lot more ideas, things that suggest themselves through the painting and through just looking at things. Sometimes you get too many ideas, and you can't put them all down, so you have to be selective.

The spaces in between the flowers or the objects are very important to me in the composition, in fact almost as important as the objects themselves. This is why I'm trying just to feel that I have got the right distances and that they're making an interesting shape in themselves.

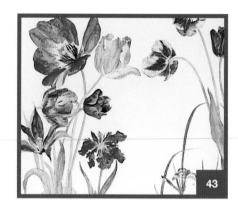

I feel this painting has come to a stage where I'd quite like to leave it. I like having the paintings around and thinking about them, and then coming back with a fresh eye. So I don't want to push on too much with his one at the moment.

This is the finished painting with quite a few additions. I've put in some different jugs and hinted at the background – I just didn't want to make it too strong. I wanted the flowers to be the most important thing in the painting. Sometimes using the jugs gives you a slightly different shape and a different kind of interest in the painting.

43 *I have built up the left-hand side of the painting and added more tulips to the middle part so that the two groups almost meet at the top, and leave an interesting shape between them.*

Opposite *The completed painting. I have put in three more jugs, given them a pale surface to stand on and added a little background colour here and there.*

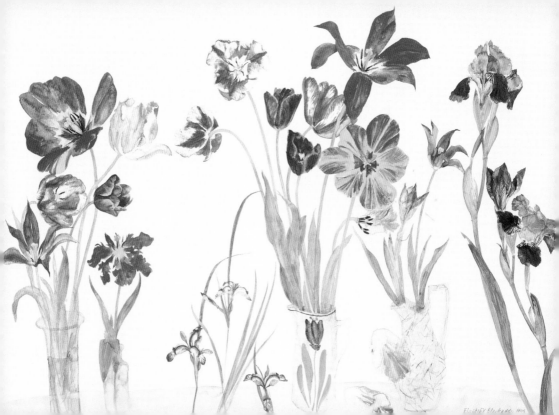

"The spaces in between the flowers or the objects are very important to me in the composition, in fact almost as important as the objects themselves."

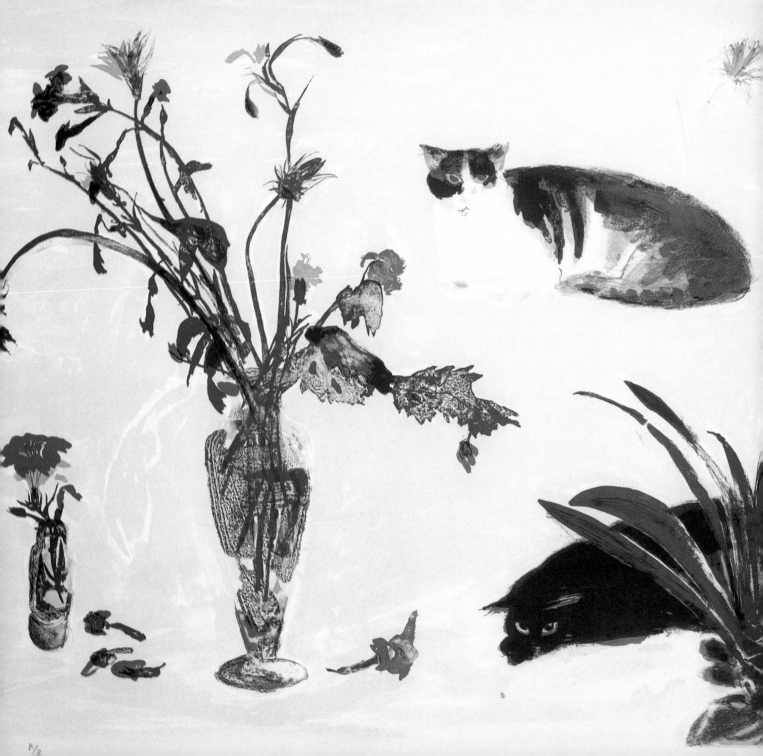

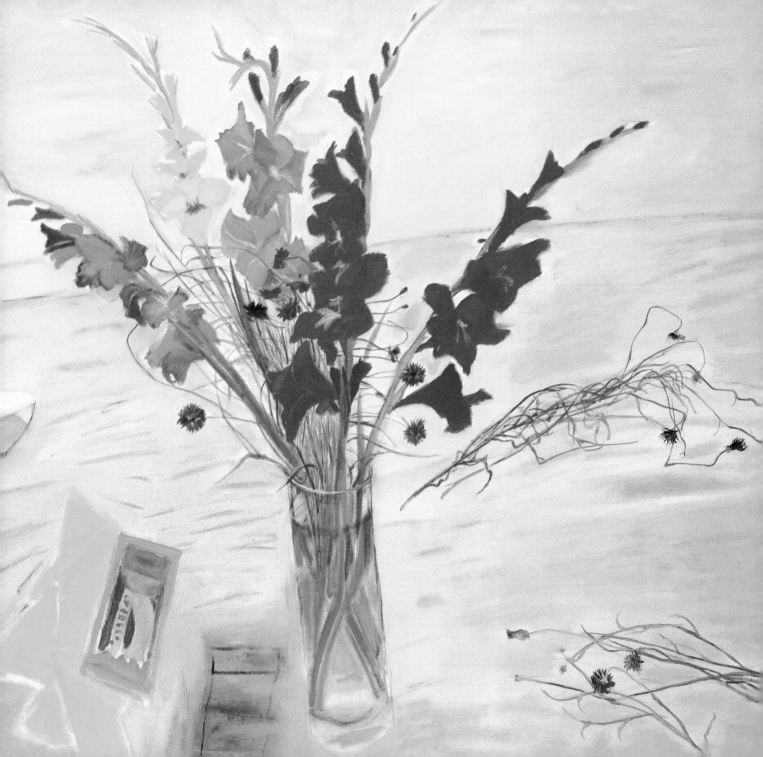

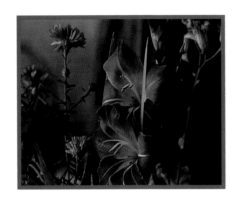

DARK GLADIOLI

I saw this fantastic gladiolus in the garden. I hadn't seen it before and it's a very, very dark purple. I thought: I have to paint it because it's the only one I have. I've painted it very quickly.

Now that I am painting in oil, I am painting in a slightly different way because I am also trying to paint in some sort of background and not just isolate the flowers, as I tend to do in watercolour. In oil you really have to integrate the flowers into the surrounding areas. I think this one would look odd if I painted it onto a white background.

In the painting opposite I have done this so that the whole area is integrated above and below the 'horizon line' running across

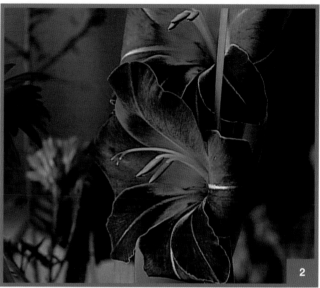

it, and all the spaces between the flowers and the objects share similar colours.

I like to use a little white in some oil colours. You can also use white in watercolour too, but I don't really do this because I feel it loses some of the liveliness and transparency of the watercolour. I used to use quite a lot of white, so it became almost a kind of gouache, but now I prefer to to use watercolour just as pure colour.

Here I am scraping out the white veins on the petals with a palette knife. Anything with a sharp point will do for this, as long as you can

1/2 *The gladiolus has an elegant stem and a soft velvety texture, which I also like, and very fine white veins on the petals.*

3/4/5 *Here I am taking off some of the violet colour with a piece of tissue and trying to catch that paler, rather smudged texture at the base of the petals.*

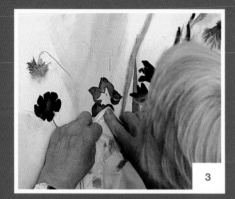 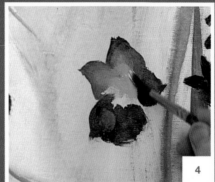 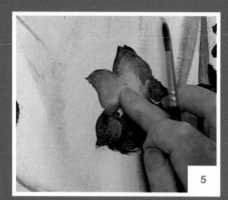

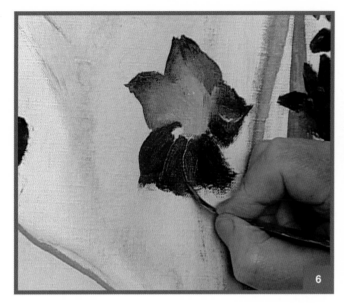

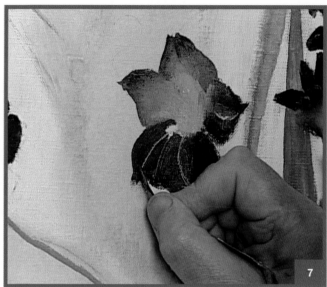

get cleanly back to the canvas beneath. I could try to paint these veins in, but they are very fine and scraping gets the effect just as well.

I think the first flowers I painted were in oil. There is a very early one just outside this studio. Every now and again I do an oil painting, but they are not nearly as frequent as the watercolours. When I started painting flowers a lot, in the late '70s I think, they were nearly all in watercolour.

I am painting in a much more detailed way than, for instance, when I painted the Italian building earlier and was really sloshing the

6/7 Scraping out the white veins with a palette knife. Any pointed metal object will do, even a nail, but you have to take care not to cut into the canvas beneath. You only want to get back to the ground.

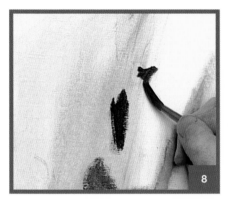

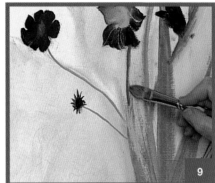

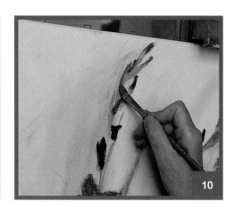

8/9/10 *Here I am putting in the shapes of the buds on the stem, and painting in some of the other stems. As soon as I bring a flower like this into the studio it starts to come out, so I have to work quickly to keep everything in scale.*

paint around. Here I am just trying to get the drawing of the individual flowers.

With oil paint you can move the paint around a good bit more than watercolour. You can scrub watercolour around too, but it tends to look a bit tired if you do that. Oil paint stands up a lot more to being pushed around.

For this colour I am using a mixture of Winsor Violet, and I'll probably put a little red into it.

What started me off with this painting was finding this fantastic flower, this dark purple gladiolus, in the garden one evening. I just felt I had to paint it, and it was only when I had to paint it quite quickly,

51

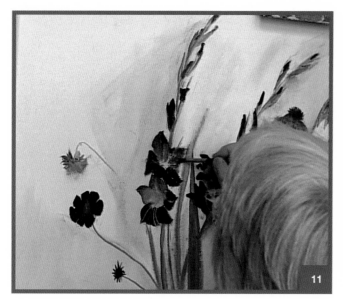

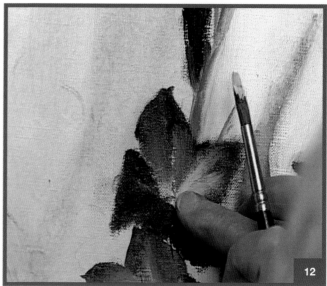

and with one or two other flowers round it like the cosmos and the cornflower, that I thought I'd get something out of this dish of fruit if I put it in with the flowers. I hadn't really planned it out very much at all, I was just so anxious to get the idea onto the canvas and get the flowers painted that I was just hoping that somehow or other I would find something that would go in the background. I wanted to make the flowers the most important thing in the painting, so the background had to be fairly secondary. I didn't want it to be too strong. Then later that evening I saw a dish of fruit in the dining room, and I thought perhaps I could use that.

11/12 *Building up the flowers on the gladiolus. Now the colour has more body. I am still working on that paler shade in the middle, and rubbing in some white with my finger.*

13/14/15 *Putting in some background colour, and using different tones to make the flowers stand out and to define the spaces between them.*

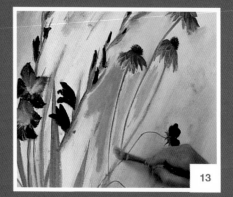
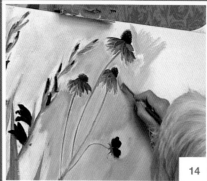
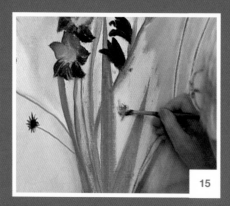

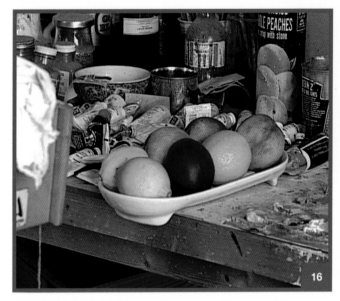 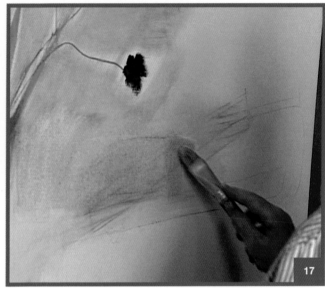

I am not sure about these fruits. I just saw them last night and I thought: I need something going across the surface, but I am not sure if that is the right thing.

That flower is a little spotted lily. Its common name is Japanese Toad Lily, it's quite small, quite pretty and it comes out late in the summer. I think it was a later addition, a little flower that was just lying there by chance and looked quite interesting.

I am just washing over with a rag with a little paint and turps on it, and spreading it over the surface to get rid of some of this white, the

16/17 *This is the fruit bowl which I thought I might use to go across the area to the right of the flowers. In the other picture I am starting to put in some lemons.*

 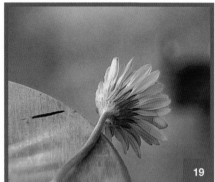

18/19/20 *This yellow flower is a gerbera. It was a little bit past its best, but I liked the shape and put two of them in the foreground.*

big areas of white anyway, so that I can look more carefully at the tonal qualities.

Now that I have managed, I think, to get the idea of the flowers and the sort of design of the flowers where I want them, I'll stop painting and consider just how important these other areas are, for instance where I suggested putting the dish of fruit.

This is now the finished painting. I have got this dark shape on the left-hand side and there is a little glass pear where the fruit dish was. Some of the colours between the flowers are a good deal stronger than they were, and I think that gives the background more depth, and a sense of space going on behind the dish.

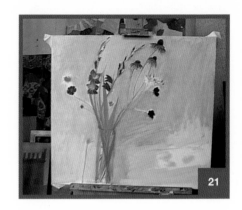

In a way the whole composition floats, rather than being grounded firmly on a tabletop or some other kind of base. This is something I quite like doing, almost without it being a conscious effort.

21 *The whole composition so far. There is still quite a lot of empty space over to the right.*

Opposite *The completed painting, to which I have added a few small objects and deepened the background colours to hold everything together.*

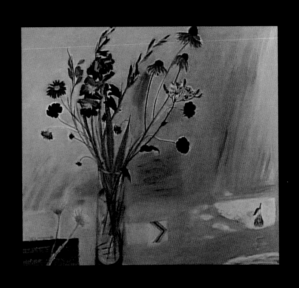

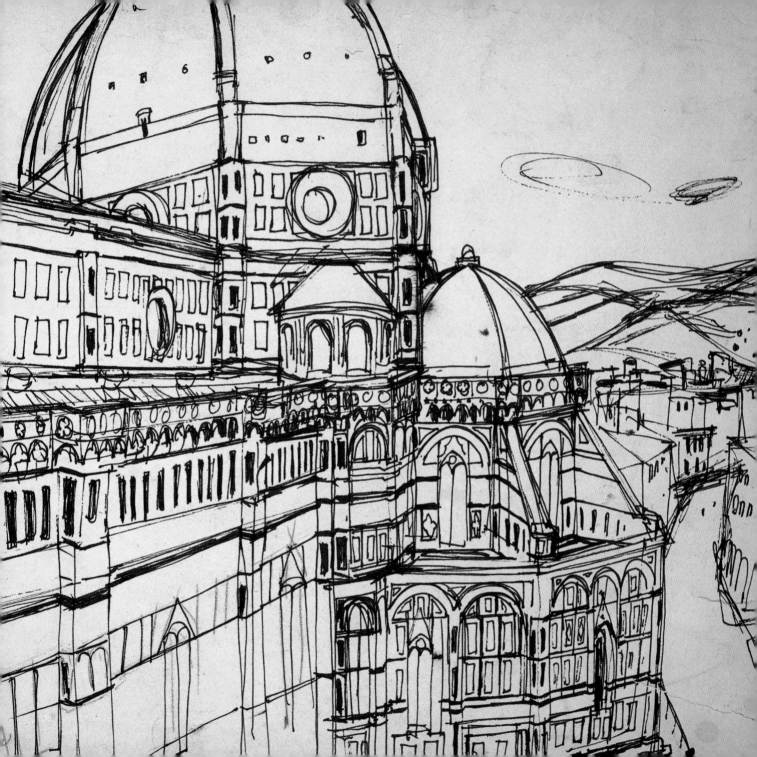

BOLOGNA

Above *A drawing I made on the spot in Bologna. I was in the Morandi Gallery opposite this building, and made this sketch through an open window in the gallery.*

Opposite *The Duomo, Florence, detail (1955), pen and ink.*

After I have been painting in watercolour for some time it is a nice change to go into the oil studio with a big brush, sloshing around with oil paint on a canvas. Also I do like to have various things going on at the same time so I can move around and come back to one as the mood takes me.

Usually, if I'm working on an oil painting I try to lay it in over the whole area and get rid of the white canvas. It is only then that you can see the whole thing. I am working quite quickly too, in this initial phase. This is a fairly big painting, so I am using a large, broad brush. Other times I'll take a rag and just cover the surface until the white in the background has gone. It's important to do this because the white

59

prevents you from seeing the tonal balance of the painting.

With this one, I've just got a rough sketch of the thing. I don't actually know what this building is, it's in Bologna, in the main square. I think it's one of the town offices. It's obviously quite an old building. It's quite interesting, all the buildings are brick, a kind of browny brick, and there are these curious kind of battlements which really have rather a look of menace about them. A lot of the buildings do look like fortresses. Also there are one or two very tall towers which are obviously look-out posts, some of them leaning in different directions. I am really just interested in the façades and the pattern of the

1/2 *Here I am laying in the colour of the building with a housepainter's brush. In oils it is a good idea to cover the surface as soon as you can because once the colour is on you can start looking at the tonal balance.*

3/4/5 *Now I am putting in those curious battlements on top of the building, and using the side of the brush for finer lines. After that I blocked in the sky.*

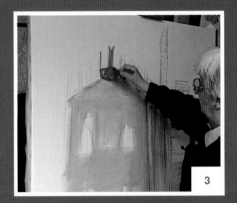

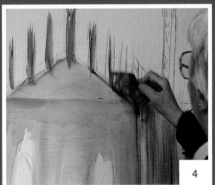

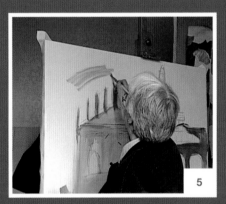

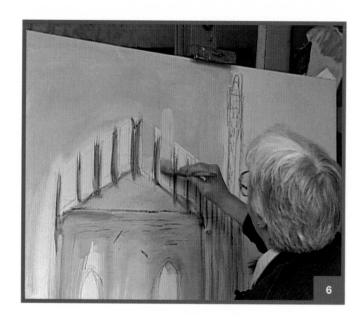

6 *Bringing the sky down between the battlements.*

brickwork and the windows and so on. This part of a building looks as if bits have been added and added in a sort of jumble, and together they make quite interesting shapes.

I usually work from sketches. They are really a very personal kind of sketches, they are not in any way finished drawings. I don't really show them at all, they are just for my information, the kind of things I need if I am going to work on a bigger scale. I suppose I have got accustomed to some kind of shorthand, either in the drawing or in the notes I write down beside it. These also help me to remember what it was that particularly struck me about the subject in the first place.

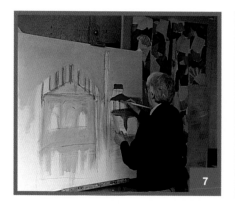

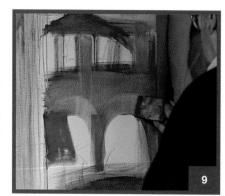

7/9 I am using earthy 'Italian' colours for this painting – ochres, siennas and various reds.

8 Referring to an earlier sketch as I go along. There is quite a lot of detail in this building that I will leave out. I am mainly concerned with the general shape of things, like these large arched windows.

The painting I am doing now has an oil ground on it. I sometimes paint straight onto the canvas, but I like a fairly fine canvas and an oil ground and then, as I am doing here, I am painting very thinly and wiping off and using turps and so on.

This colour is a mixture of Cadmium Red and Cadmium Scarlet. I don't want to be too literal about it. I have got some photographs of the subject, and I might refer to them for some of the drawing, but it is difficult using photographs because you find you tend to try and copy too much and I don't want that at all. Also there is too much, I want to eliminate a lot of stuff anyway, and you are inclined to see almost too much in a photograph. In this building, for example, there is actually a row of shop fronts on the ground floor, but I am not going to include them because in this painting I want to concentrate on the

63

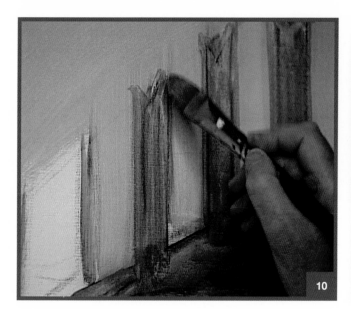

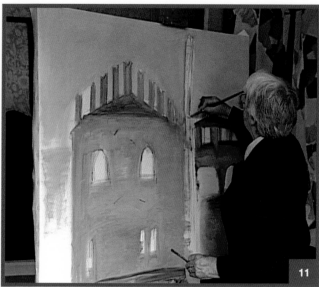

simple shape of the façade, and that kind of detailing would
be superfluous.

Even though I maybe noted down in the sketch what the colours were,
when you go up in scale things change. Some of the tones of the tower
against the sky have changed, and I want to make a difference between
this bit and the one next to it. I think I'll keep the sky fairly light.

Here is the finished painting. I think it was really the façade of this
building that first attracted me to the subject. The texture of the
brickwork and these funny little iron bars going across the front of it.

10 *Touching in the unusual V-shaped
tips of the battlements.*

11 *This is a tall, slender tower which
stands at a very slight angle behind
the building.*

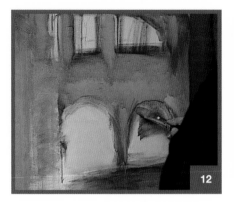 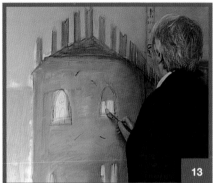 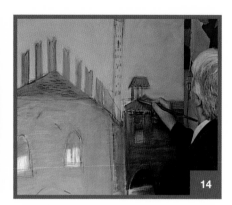

12/13/14 *I am putting in some finer lines to sharpen the shapes of the windows but keeping these fairly approximate, like the rough surface of the façade.*

Also the battlements – quite a lot of the buildings had these quite tall shapes, I don't know why. And then there are the shapes of the towers in the background, the very tall thin ones lying at a slight angle.

I found when I was painting this particular subject that the paint was very wet, and it gets to the stage where you just want to leave it to dry. Then, when I was thinking about the subject, I thought of different designs using the building, so I went on to do a series of quite small paintings where I could try out different compositions and use different colours to give the buildings a different emphasis. That was quite fun, and then I came back to this painting, the first one, and finished it, and it has really changed quite a lot since I first approached the subject.

65

I find that a lot more ideas are generated when you are actually doing a painting, and that is why I sometimes go on to do variations. So it has become a kind of series, which I never really intended it to. I am not particularly interested in making pictures like this look too realistic or anything. What I am looking for is an idea of the design, and with this one it was really just the simple shape of it.

15 *Some of the small studies I made while I was working on the big painting.*

Opposite *The completed painting. I have put in the iron supports which stud the façade, and changed the colour of the sky*

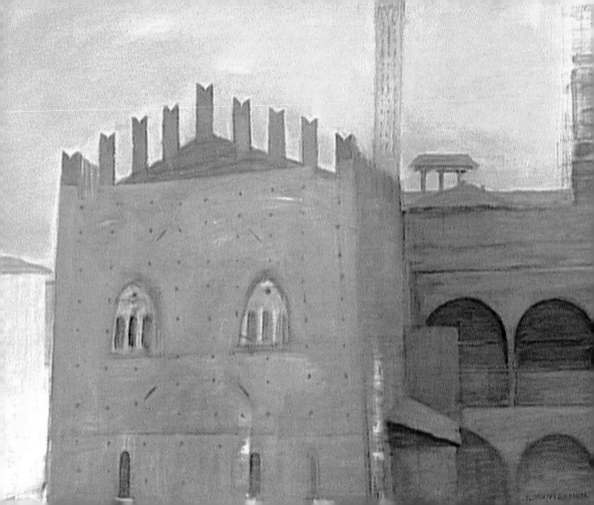

"I do like to have various things going on at the same time so I can move around and come back to one as the mood takes me."

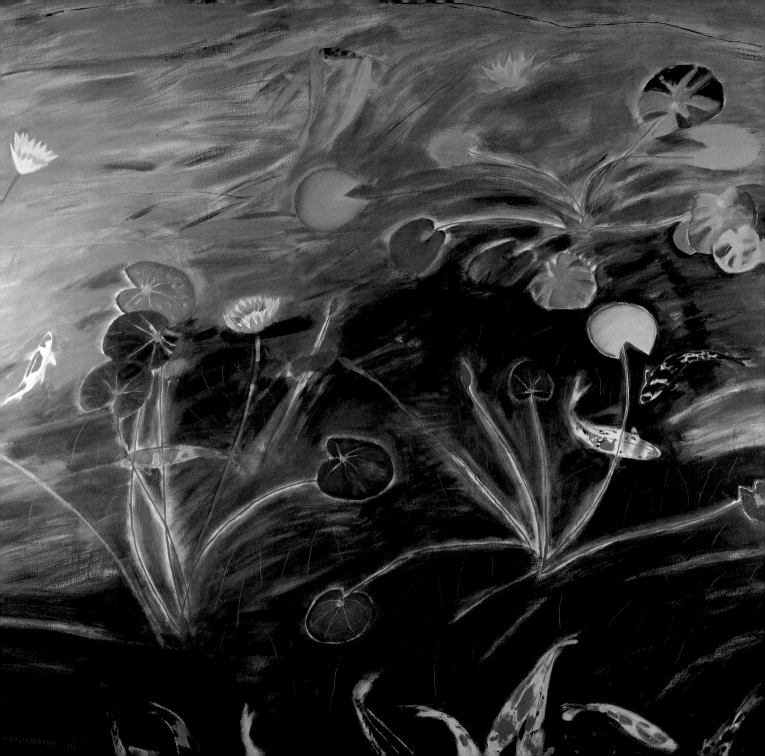

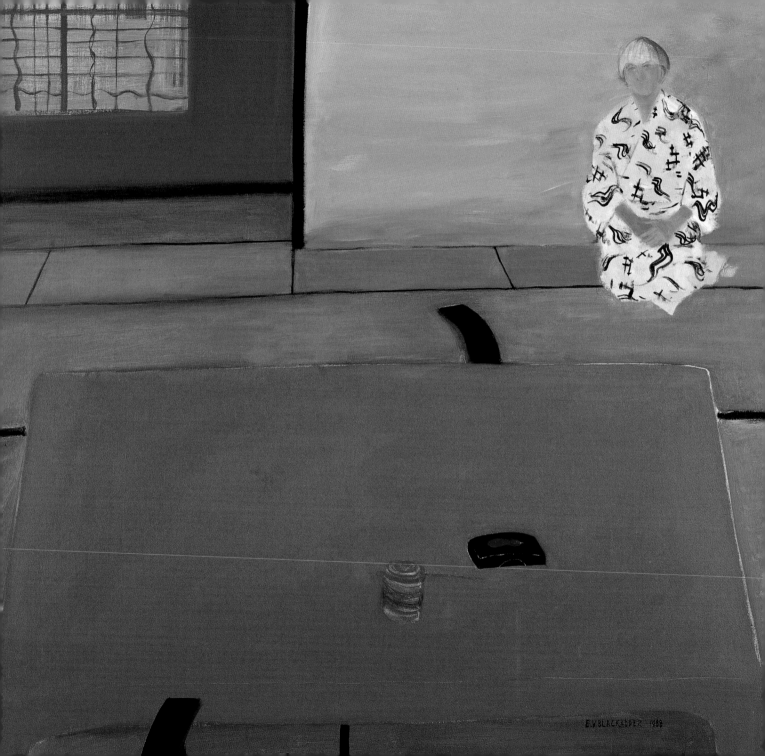

KIMONO

Previous page *Water Lilies and Koi Carp (1993), oil on canvas.*

Opposite *Self Portrait with Red Lacquer Table (1998), oil on canvas. I was very struck by the wonderful red colour of the table and made a sketch of the room when I was in Japan. Then I put myself into it later.*

Above *This is the kimono I am going to paint. In Japan they hang them on bamboo poles, and I want to retain that in my painting.*

I think, like a lot of painters, I am very conscious of other paintings and other cultures, and probably from studying the history of art I became interested in different forms. Chinese and Japanese art had always been something that I was very conscious of. Also, when my husband and I went to America and saw some of the Oriental art, particularly in the Freer Gallery in Washington, DC, these were things I had never really seen before. And in Chicago, in the Chicago Institute, I saw Japanese screens and Japanese furniture and so on, and I think that made me even more aware of it and I became much more interested in it. We both wanted to go to Japan, I think the first trip was in '84 or '85. I found it very rewarding. It wasn't a sudden sort of influence on my work, I think the influence was there from what I had

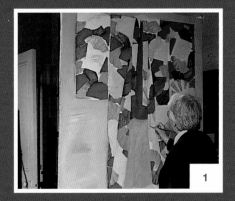

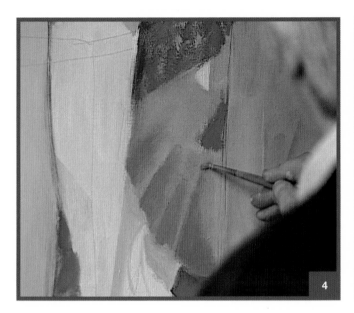

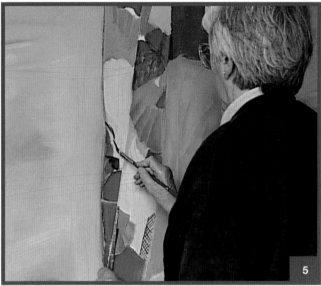

1/2/3 *Although this is a fairly large-scale canvas, I am going to limit my colour range to four basic colours. I will probably keep fairly closely to the broad design of the original.*

4/5 *Here I am working on one of the fan shapes in the pattern, and adding a ribbon effect over the lighter area.*

seen in books and exhibitions, but it became much stronger when I saw these things.

Like a lot of painters, I have always collected things. We tend to be magpies, we collect what is called 'source material' – so I collect everything. I am not a collector of valuable objects at all, they are really things that visually I like or I think that I would like to paint, or they make some kind of connection for me. When I came back from Japan, I brought quite a lot of material with me and, as well as being nice objects for me – at least I think they are interesting objects – they also give me a kind of recollection of a place and a time, and this is

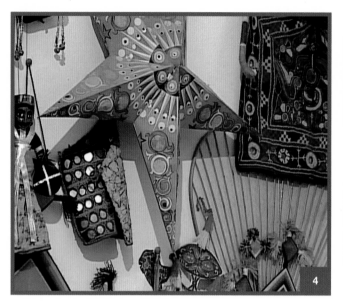

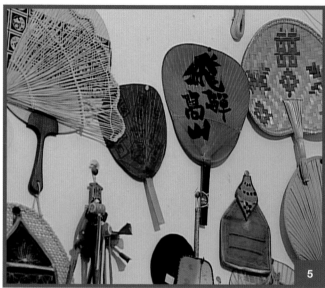

something that I try to get across in paintings, even if I do sometimes adjust the shapes and tones of the original to suit my designs.

This kimono is one of a number that I have collected over the years during my visits to Japan. I like the design and the shape of them, and the way they make a complete composition almost by themselves. With this one, I have painted it in the traditional way that kimonos are displayed in Japan, hanging from a bamboo pole. That gave me the basic design of the painting, and I have kept quite close to the shape of the hanging kimono, rather as you do when you are painting a portrait, and once you have arranged your subject in the pose you want, then

4/5 Some of the objects I have collected over the years and sometimes put into my paintings. Those on the left are Indian. The big star shape is made of paper and has holes in it so that a light can shine through. I also like the small piece of embroidery with the little rounds of mirror glass. The other photograph shows various Chinese and Japanese fans, some of them quite delicately decorated.

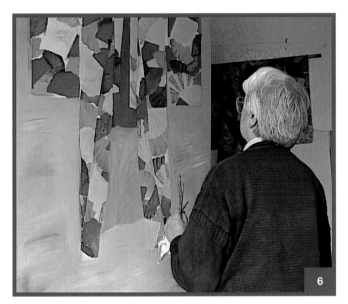 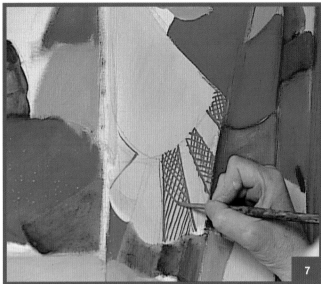

6/7 *Here you can see how I have simplified the patterns of the original kimono while at the same time trying to get something of the spirit behind its fairly intricate design.*

the main element of your composition is fixed and you paint the subject in that position.

Of course, if you want to simplify the way a piece of clothing hangs, or the way the folds in the material go, then you can do that too. And to some extent I have done that here with the kimono. This is something that can be an almost unconscious process, because what you are doing is leaving out the things that you don't want in your painting. The actual kimono had quite a lot of detailing in it, which I have not included in my painting.

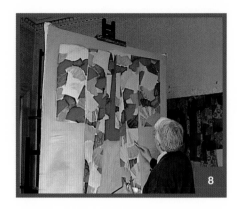

I liked the colours in this kimono, but again I simplified the actual pattern as I went along, and also the colours. For example, what you see here as almost white areas are in fact more of a creamy colour in the original. This is also a question of scale. The kimono itself is much larger than the area of this painting, and so I wanted to limit myself to a more simple arrangement using mainly the four colours of red, blue, yellow and white for the kimono, and a contrasting, paler background against which the kimono would stand out.

8 *Now the main elements of the design are in place.*

Opposite *The completed oil painting. I have put in some more fan shapes on the kimono, and behind it have used a traditional Japanese pattern of interlinked squares that you often see in textiles. Some people may read these as tiles, but that was not actually my intention.*

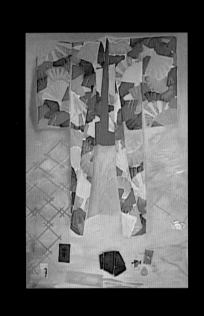

"... as well as being nice objects for me – at least I think they are interesting objects – they also give me a kind of recollection of a place and a time, and this is something that I try to get across in paintings."

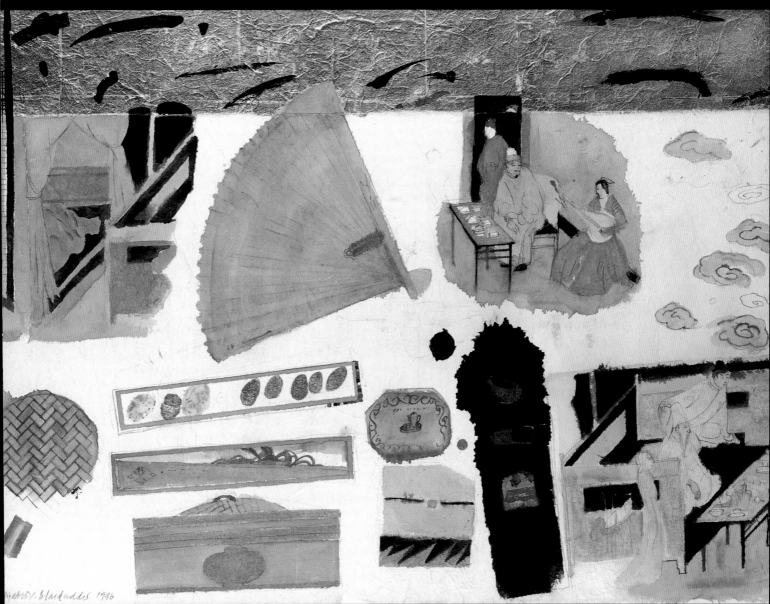

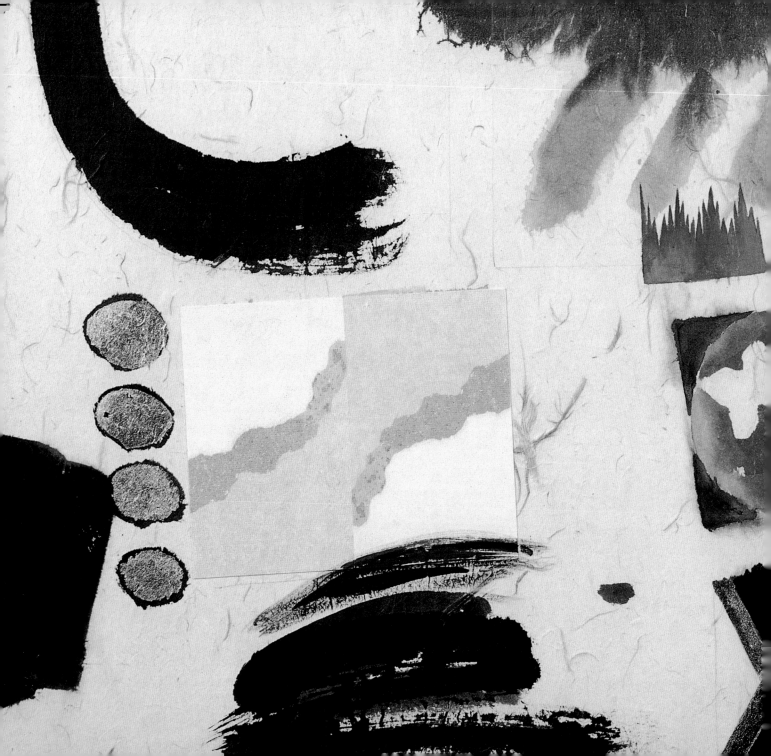

JAPANESE STILL LIFE, BLACK & SILVER

Previous page *Chinese Tea Room (1996), watercolour.*

Opposite *A detail of the completed painting shown on page 91.*

Above *The design at an earlier stage, before I had resolved what to do on the left-hand side.*

I have been using this format of a long scroll shape for some years. I suppose this is again a Japanese influence which developed from seeing some of their scrolls, especially in the National Museum in Tokyo. They have the most beautiful scrolls where, as you move along, you read the painting. You don't take it all in at once, and I quite like that sense of moving across a painting.

It is nice to come back and look at something with fresh eyes, but it also takes a little while just to get into the feeling or the mood of a new painting. With this one, I'll probably go gently to start with until I can feel where I am going. Sometimes I stick fairly closely to the object and other times I take off from it and it becomes something different.

I just see how it goes. This is a little toy, it's a model of a mask from a Noh play, you see quite a lot of them in Japan, they are quite lovely things.

I experiment a lot with Japanese or Chinese or Indian hand-made paper. It becomes so much part of the painting because the surface varies so much. There may be pieces of texture, sometimes quite strong texture, in the paper which almost become part of the painting itself. You can see this in the painting on page 85, where the grasses in the paper play an important part in the composition. Also some are very transparent papers and others are very soft absorbent papers, so

1 This is a model of a mask. I am moving the box around to see where it might fit into the painting.

82

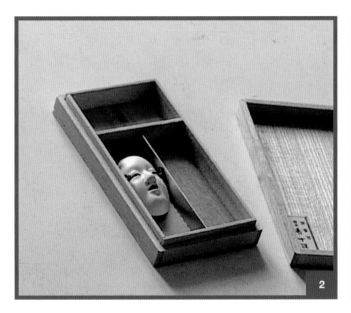 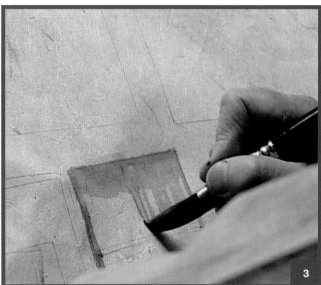

2 *The mask and the box in more detail. These masks are used a lot in Noh plays.*

3 *Putting in some of the grain on the inside of the box.*

they really affect the way that you are going to paint. I have been using these kinds of paper for quite a long time now.

I didn't want very much strong colour in this, but this will disappear, or some of it anyway. It will be covered up, but I also want a colour underneath because it gives a quality to the relief that may be black, or a warm colour like red.

I see quite a close connection between these different kinds of painting. My mind is working very much in the same way in terms of the balance that I'm trying to create, the way I'm trying to lead

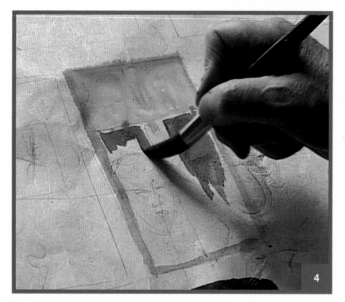

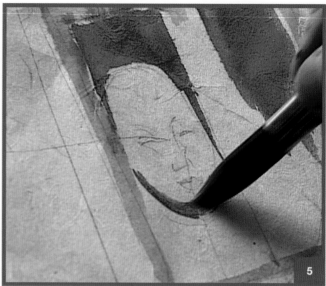

whoever is looking at the painting through it, whether I am painting flowers or semi-abstract forms. I am using colour to create a particular kind of mood, perhaps less so in the flower paintings where the colours dictate it. But I don't see that I become almost a different person painting these paintings. My concern in all of them is with this kind of visual language.

This is a very thick ink that you can dilute, and I think I have put too much water in it. I really want it fairly dense, a rich black.

Some of these shapes are based on objects, others I am using just as a

4/5 *Here I am adding a warm red colour to make the mask stand out.*

Opposite *Still Life with Fish and Japanese Paper Weights (1986), watercolour. Although this consists of two separate pictures, the heavily textured paper helps to link them together.*

84

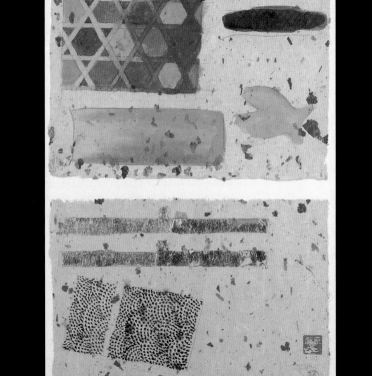

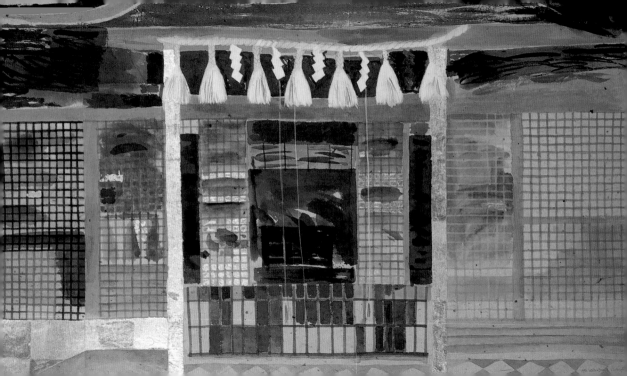

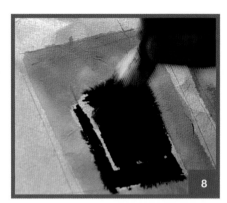

6/7/8 *Some of the shapes I am adding. The long curved mark is like a calligraphic sign. I put it in to add variety because several of the other shapes were rectangular. The black square is a companion to the mask next to it.*

Opposite *Large Shrine, Kyoto (1991), watercolour.*

link. Also, as well as the shapes, the blank spaces between them are very important to me – as I said about the flowers earlier – so I am always trying to consider them as well as what I am actually painting. For instance, is that area right, does it need something else or does it need a different scale? I was using that curved mark because I felt that some of the shapes over here were very geometric, rectangles, squares and so on, and I wanted something a bit looser so they are not all too static.

These little shapes look like shells and are lacquered inside. They're really for holding chopsticks, and are very pretty, not too regular in shape.

Some of these objects may become ink sticks. They're little brass

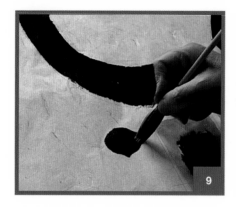

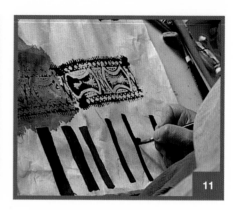

weights to put down when you open out a scroll, to keep the thing open, and they're really quite pretty. In the painting they break up the rectangular shapes. Quite often I choose the things I collect because I like the simplicity of the way they are made, the way ordinary utensils are made, like spoons for mixing or for cooking. You just look at them and you think: what a good idea, it's just so simple. I think that is why I started collecting so many things. I just liked the look and the feel of them too, and the material they were made of. It seems such an odd idea to make a plate that shape, and yet it is so nice and asymmetrical.

I think this composition is getting a bit too heavy. So this is where I will probably go and walk round and look at all my things. Sometimes you're just wondering what to put in next and you think: 'Ah, the ideal object,' as you remember it. In bigger areas I'll apply a gold leaf,

9 *Beneath the curved mark I am putting in a vertical row of circular shapes, rather like small shells.*

10 *The black 'anvil' shape near the bottom comes from a brochure made of folded paper.*

11 *These stick shapes are derived from the brass weights that keep a scroll in place when it is opened out. They are also like Japanese ink sticks – solid blocks which you buy to make up your own ink. You rub the stick on a piece of stone and add water.*

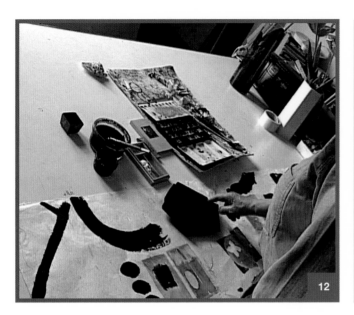

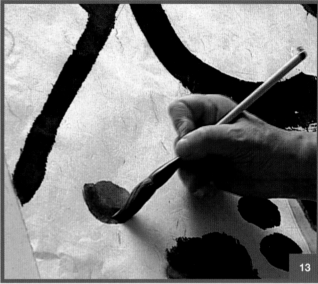

12/13 *Now I am trying to find a place for this strange asymmetrical black plate. Eventually I put it under the calligraphic marks in the bottom-left corner.*

particularly on top of some of these blacks, but I can't do that until it is stretched onto a rigid background - a piece of board - so that really has to wait until the end. That also means I don't really see the whole effect until it is almost finished.

I started to use gold leaf quite a long time ago. I have always been interested in Romanesque and Byzantine paintings and manuscripts. I used gold paint to start with, and then I moved on to gold leaf. I think it was seeing Japanese screens that first made me want to try putting it into some of my paintings.

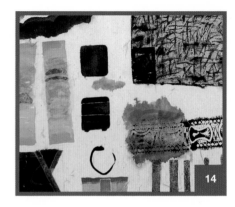

You can look at the finished painting in lots of different ways, I think. It's a personal thing to me, obviously, because all these shapes and objects have a special relationship which I am familiar with. Somebody else looking at them won't read that into them, but to me that doesn't really matter. Another way of looking at it is as a sequence, almost like a passage of music where you get quiet passages, busy passages or you change the pace of the thing. Also I am trying to create a mood, and that again is probably a personal thing. Somebody else may see the same thing, which is good, or they may see something else or they may not see anything at all!

14 *In this detail I have added the gold leaf at the top and also taken quite a bit of colour off the row of ink sticks. You can see that the spaces between the objects are also an important part of the composition.*

Opposite *The completed painting. Towards the left I have painted out the mask and stuck on a Japanese card. The card is an upright rectangular shape, and I have extended the design to the left to make it double the width.*

Following page *Still Life with Tulips, watercolour.*

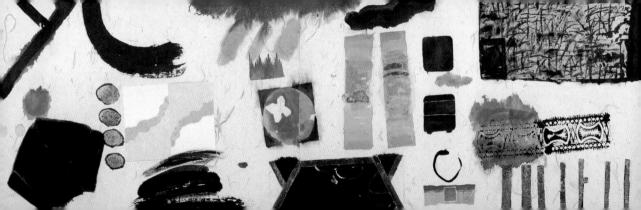

"Another way of looking at it is as a sequence, almost like a passage of music where you get quiet passages, busy passages..."

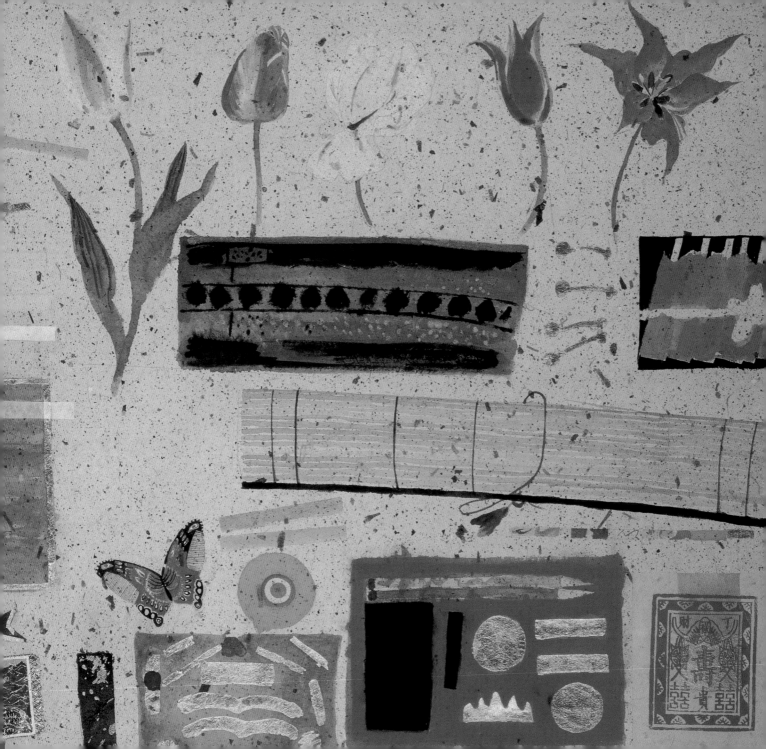

SOLO EXHIBITIONS

1959	57 Gallery, Edinburgh	1977	Middlesbrough Art Gallery and Museum
1961	The Scottish Gallery, Aitken Dott, Edinburgh		Hambledon Gallery, Blandford, Dorset
1965	Mercury Gallery, London		Stirling Gallery, Stirling
1966	The Scottish Gallery, Aitken Dott, Edinburgh	1978	Mercury Gallery, London
	Thames Gallery, Eton		Yehudi Menuhin School, Stoke D'Abernon
1967	Mercury Gallery, London	1980	Mercury Gallery, London
1968	Reading Art Gallery and Museum Lane Art Gallery, Bradford		Oban Art Society
1969	Mercury Gallery, London	1981	Loomshop Gallery, Lower Largo, Fife
1970	Vaccarino Gallery, Florence		Bohun Gallery, Henley-on-Thames
1971	Mercury Gallery, London	1981–2	Scottish Arts Council Retrospective Touring Exhibition: Edinburgh, Sheffield, Aberdeen, Liverpool, Cardiff, London
	Loomshop Gallery, Lower Largo, Fife		
1972	The Scottish Gallery, Aitken Dott, Edinburgh	1982	Mercury Gallery, London
1973	Mercury Gallery, London		Mercury Gallery, Edinburgh Festival Exhibition
1974	The Scottish Gallery, Aitken Dott, Edinburgh Festival Exhibition		Theo Waddington Gallery, Toronto, Canada
		1983	Lilian Heidenberg Gallery, New York
	Loomshop Gallery, Lower Largo, Fife	1984	Mercury Gallery, London
1976	Mercury Gallery, London	1985	Mercury Gallery, Edinburgh Festival Exhibition
	Loomshop Gallery, Lower Largo, Fife	1986	Lilian Heidenberg Gallery, New York

1987 Henley-on-Thames Festival of Music and the Arts

Salisbury Festival

Glasgow Print Studio

1988 Mercury Gallery, London

1989 Welsh Arts Council Retrospective Touring Exhibition:
Aberystwyth, Brighton, Bangor, Cardiff, Bath, Leicester

1990 Abbot Hall, Kendal

1991 Mercury Gallery, London

1992 DLI Museum, Durham Retrospective Exhibition

1993 Glasgow Print Studio, *Orchids and Other Flowers*

Mercury Gallery, London

1994 The Scottish Gallery, Aitken Dott, Edinburgh
Festival Exhibition

1996 Mercury Gallery, London

1998 Glasgow Print Studio

Mercury Gallery, London

The Scottish Gallery, Aitken Dott, Edinburgh

1998-9 Glasgow Print Studio, touring Great Britain and Ireland

1999 Mercury Gallery, London

1999-0 Scottish National Gallery of Modern Art

2001 Talbot Rice Gallery, University of Edinburgh,
Edinburgh Festival Exhibition

2002 Browse and Darby, London

SELECT BIBLIOGRAPHY

Judith Bumpus, *Elizabeth Blackadder*, Oxford, 1988

Deborah Kellaway, *Favourite Flowers: Watercolours by Elizabeth Blackadder*, London, 1994, reprinted as *Irises and Other Flowers: Watercolours by Elizabeth Blackadder*, New York, 1995

Duncan Macmillan, *Elizabeth Blackadder*, Aldershot, Hampshire, 1999 and Brookfield, Vermont, 1999.

VIDEO

The Art of Elizabeth Blackadder (2000), made by APV Films for the Royal Academy.

ACKNOWLEDGMENTS

A Sears Pocknell book

Editorial Direction	Roger Sears
Art Direction	David Pocknell
Editor	Michael Leitch
Designers	Jon Allan & Chris Bell

This book is adapted from the video: *The Art of Elizabeth Blackadder*
All video images copyright © 2000 Artwork Films Ltd.
Video produced and directed by Anthony Parker for APV Films
Video available from

APV FILMS
6 Alexandra Square, Chipping Norton, Oxon OX7 5HL

British Library Cataloguing-in-Publication Data
A catalogue record for this book is available from the British Library
ISBN 1-903973-07-4 (hardback)

Distributed outside the United States and Canada by Thames & Hudson Ltd,
London. Distributed in the United States and Canada by Harry N. Abrams,
Inc., New York

Originated in Hong Kong and printed in Spain by Imago

RA Publications, Royal Academy of Arts, Burlington House, Piccadilly
London, W1J 0BD, T 0044 (0)20 7300 5660, F 0044 (0)20 7300 5881

Half-title page illustration: *Orchids*, watercolour
Title page: *Orchid*, etching
Contents page: *Irises*, watercolour

Other works appearing in the book were photographed by J W J Mackenzie,
AIC Photographic Services

The paintings on pages 17 and 57 are in the collection of Glasgow Museums:
Gallery of Modern Art